THE OIL PAINTING BOOK

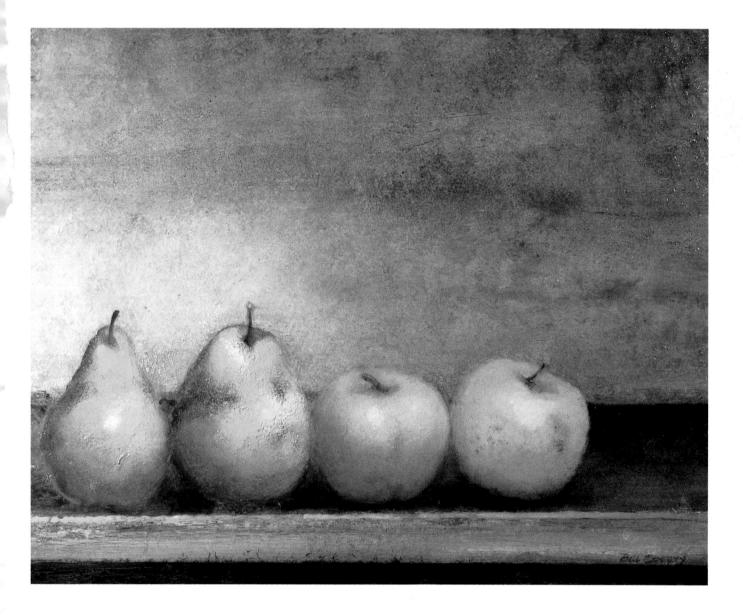

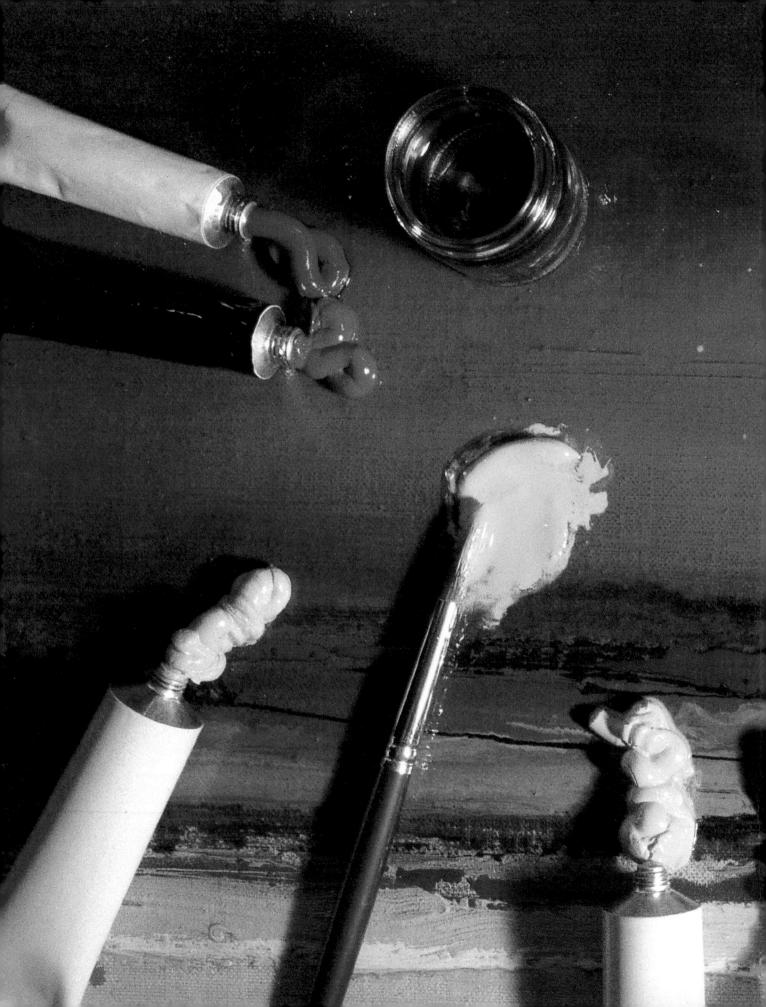